Make an Abstract Wall Mural for Beginners

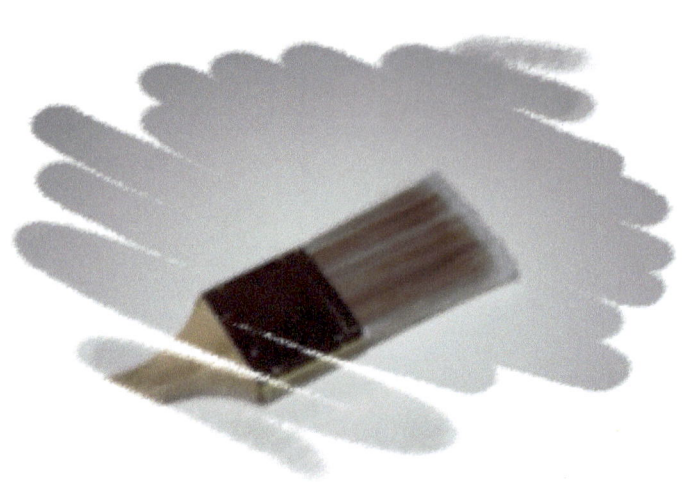

Your First Wall Mural

April Showers

Level-Easy

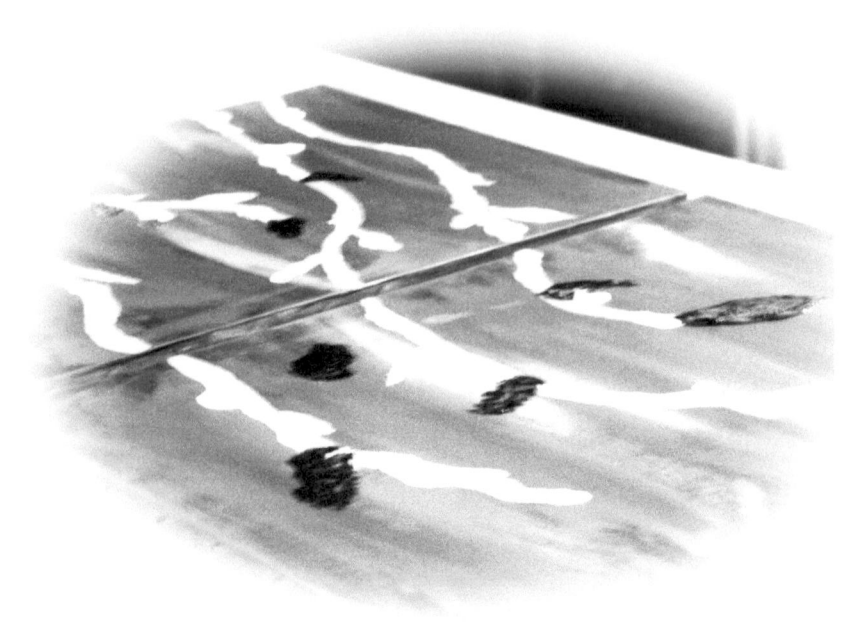

Items needed

18 by 24 or larger pre stretched primed canvas (2)

Sea Sponge

2 inch polyester acrylics paintbrush

1 inch polyester acrylics paintbrush

Paper towels

Clean, throwaway damp rag

Old tweezers

Non-toxic Acrylic Paint Colors Recommended:

Dark Gray
Medium Gray
Light Gray
Deep Black
Reddish Pink
Deep Sea Green
Cream/Flesh color
Acrylic medium for thinning

For Orange

Preparation:

Easy to follow instructions

Gather your items and go to a ventilated area and set up your items for use.

Lay the canvas panels side by side like they would be if hung on a wall.

Open your dark gray paint and squirt a modest amount on both panels.

Gently swipe paint across canvas until it lightly covers it with your 2 inch brush. Do not leave bare patches.

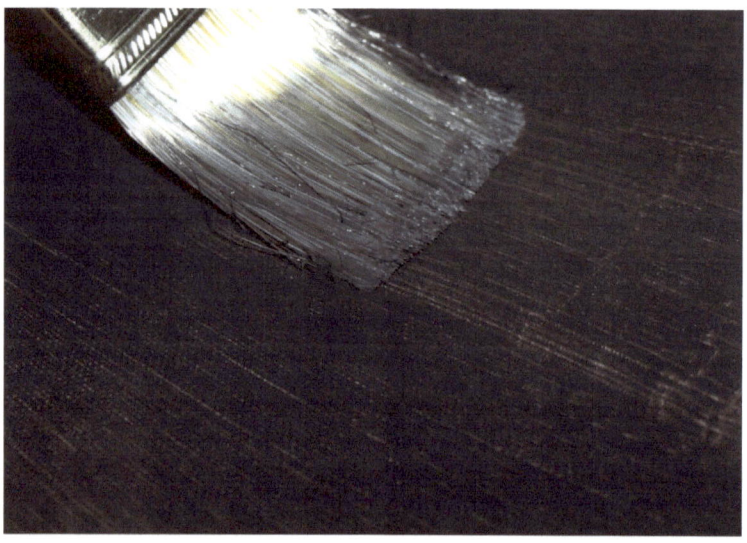

Make sure that you paint the sides too!

Using the tweezers, pick out any stray hairs that may be stuck to the canvas.

Allow the paint to dry just a little bit….about 3 minutes or so.

Do not clean the brush off yet.

Squirt a generous amount of medium gray into staggered lines as shown.

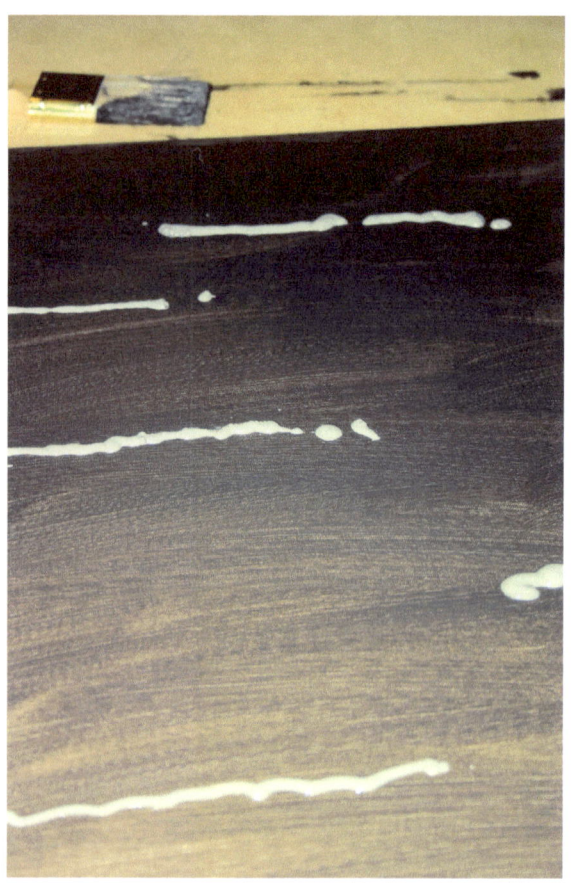

Use your imagination and place them wherever your mind wants them to go.

Again, with the 2 inch brush gently swipe and blend patiently.

Pick stray hairs off with tweezers again and allow the canvas panels to dry for about 2 minutes.

Without cleaning your brush, squeeze on quarter size gobs of light gray paint about 8 inches apart as shown and gently blend. These are your clouds that are illuminated by the moon.

If your paint gets too thick, mix in some medium into the paint and continue.

Allow your panels to dry completely. Check it over for bare spots. Recheck the sides to make sure that they are nice and painted.

Now is the time to clean off your brush with warm water. Rinse all of the paint out of it and blot dry with paper towel. Clean up any stray paint that may have flicked around with your rag.

Any blobby areas can be lightly brushed out with clean brush or paper towel.

When your panels are completely dry, take your one inch brush and medium gray paint. Gently tap in and blend in the paint any place that you see faint spots on your canvas.

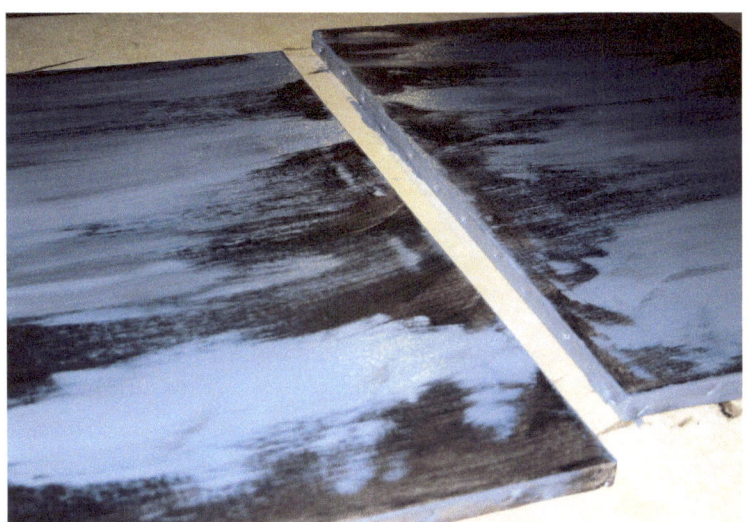

Without cleaning the brush, load it with a generous amount of reddish pink paint. Slowly slide the edge of the brush in a single motion over both panels to form a flowing branch. Repeat until you have as many as you like. Take your time with this step. It will make a big difference in the end.

Allow these thick branches to dry fully. This will take some time. Wipe the brush off on the paper towel. There is no need to rinse it yet.

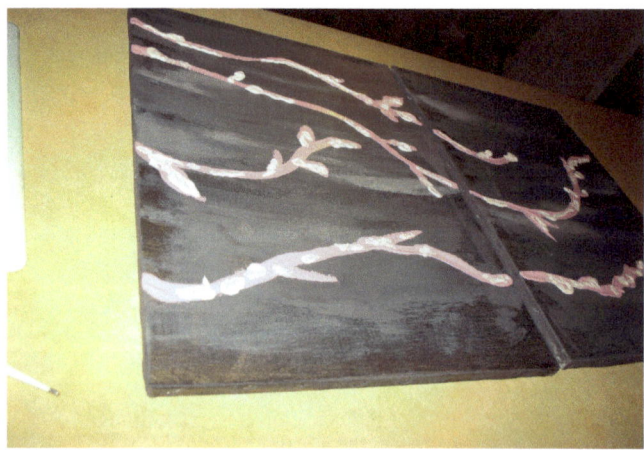

Tapping in some cream colored paint will add light and dimension wherever you desire.

Dripping the cream colored paint slowly makes some really pretty effects. Experiment with it. Have fun with it!

Allow that to dry fully.

Wipe off the brush again and get out as much of the paint as possible then tap in deep green leaves. These leaves should not be drawn in but simply tapped in wherever your mind wants a leaf.

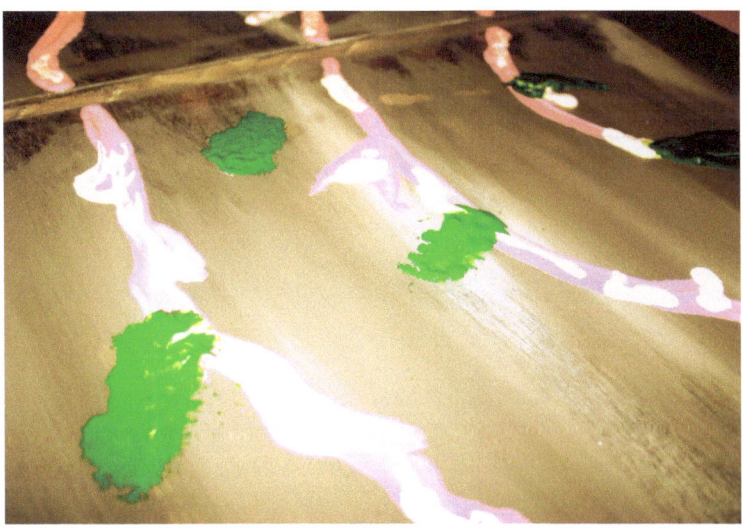

For thinner leaves, pull out the corners of the paint like this to make a cat's eye effect.

Allow your panels to dry again.

Now we will add on the pretty blooms. Mix a small amount of dark gray with the reddish pink to your liking. Tap in your blooms thick and generous. We want the paint to stand up as much as possible. Allow your blooms to fully dry. Notice the height on the paint.

Clean your brush off with water and dab dry…wipe up any messes and now it is time to have fun with the sea sponge.

The darker the shadows appear, the more your painting will appear to light up!

Tap a generous amount of black paint into the sponge and press it wherever you want your ethereal night clouds to be.

The harder you press with the sponge, the less
Of a cloud effect you will get as far as space or "air-ness"

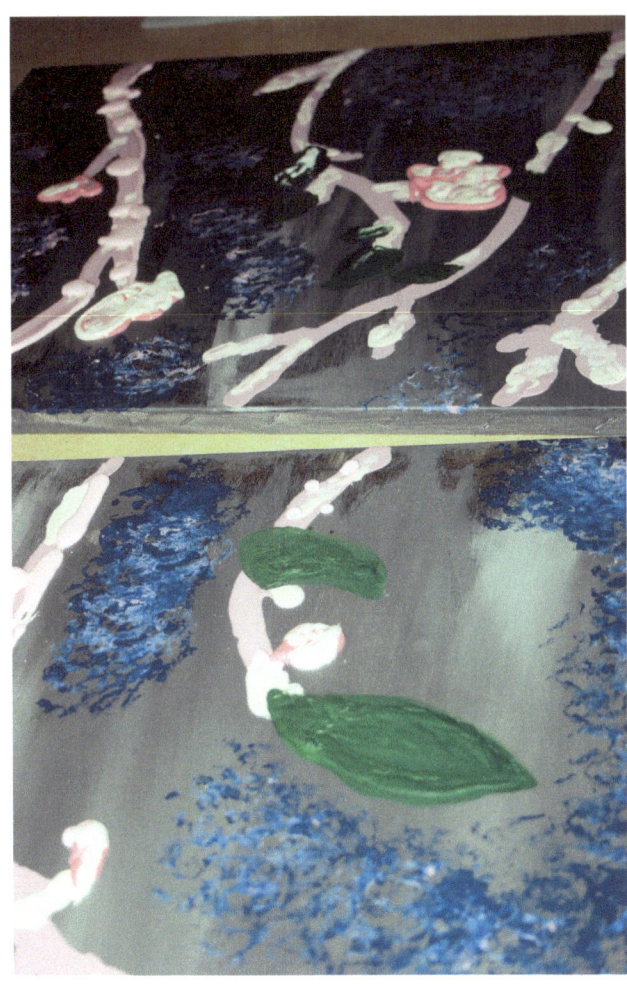

Take your time and enjoy!

Touch up your painting if you wish, sign and take it outside to gloss if you wish.

If you want a really nice finish, I recommend uv protecting crystal clear gloss after your painting as fully dried..

Find out more at www.allysonricketts.com

About The Author

Allyson Ricketts was raised
in a modest East Coast town in the Appalachian Mountains.
She has been doing art since she was old enough to steal her mother's
expensive cosmetics and paint on the walls.

Fun, easy, fresh ideas.

Free online art clubs at www.dreamportrait.com

Other easy to follow instruction books:

Painting Rock Portraits

Drift Wood Art

Watercolor for the Beginner

Use this sheet to write down your shopping list for art supplies or add in your own notes and ideas.

www.ingramcontent.com/pod-product-compliance
Lightning Source LLC
Chambersburg PA
CBHW041120180526
45172CB00001B/356